Let's Get Started!

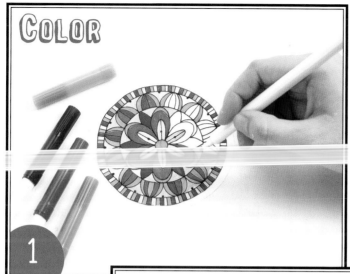

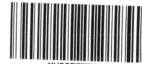

can you hang in your house? Now you can find a purpose for all of your colored art with the wonderful new colorable stickers inside this book.

From greeting cards to party decorations to home accents, gifts, and more, your very own colored stickers can add signature style to just about anything.

1 Color: There are more than 250 designs included this book. Be sure to check out the Coloring Tips on pages 2–3 to learn some great techniques.

2 Peel: Each design is die-cut so that you can easily pull it out of the book. Avoid tears by starting at the widest part of the sticker and working slowly around any intricate shapes.

3 Stick: Perfect for a variety of surfaces, these stickers will adhere to just about anything, including wood, glass, metal, and more. Non-porous, clean, smooth surfaces are best.

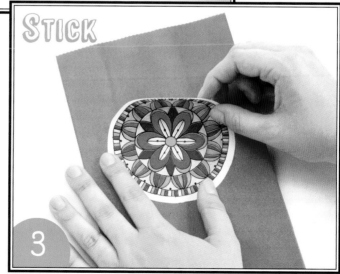

Coloring Tips

Coloring Media

These stickers are printed on high-quality paper and are great for coloring with markers, gel pens, colored pencils, and more. You can get many different effects by using different media, and even combining different media together. Feel free to experiment on whatever white space you can find on the sticker pages in this book to see how the different tools work.

Smooth out areas colored with marker by going over them with colored pencils. Start by coloring lightly, and then apply more pressure if needed. The top swoop in the image below was done in purple marker overlapped with white and light blue colored pencils; the bottom swoop was done in yellow marker overlapped with orange and red colored pencils. Markers and gel pens also go hand in hand, because markers can fill large spaces quickly, while gel pens have fine points for adding fun details. White gel pens are especially fun for drawing over dark colors, while glittery gel pens are great for adding sparkly accents.

Shading is a great way to add depth and sophistication to a sticker. Even layering just one color on top of another color can be enough to indicate shading. And, of course, you can combine different media to create shading.

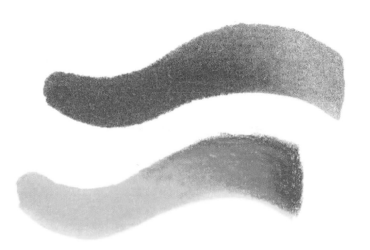

This flower was colored with markers; shading added to the inner corners of each petal with colored pencils creates a sense of overlapping.

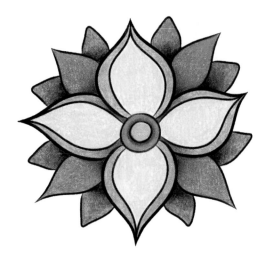

This flower was colored and shaded entirely with colored pencils. See how the texture looks very different from the first flower?

Basic Color Theory

If you aren't familiar with color theory, here is a quick, easy guide to the basic types of colors. Work your way from primary colors to secondary colors to tertiary colors, combining different tones to create all kinds of different effects. Remember: this is information to get you thinking, not a set of rules you have to follow!

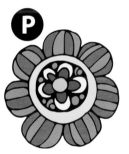

 Primary colors: These are the colors that cannot be obtained by mixing any other colors; they are yellow, blue, and red.

 Secondary colors: These colors are obtained by mixing two primary colors in equal parts; they are green, purple, and orange.

 Tertiary colors: These colors are obtained by mixing one primary color and one secondary color.

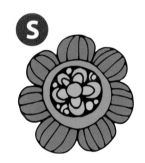

Choosing a Color Palette

Color can be a great way to express yourself and define your mood. When you sit down to color, ask yourself, "How do I feel today?" and "How can I use color to express that feeling?" Included below are a few color palettes paired with the emotions that those combinations tend to invoke. But keep in mind that everyone is different, and that's what makes art so exciting. Use these palettes as a starting point and see how they make you feel. Try adding or taking away a color to customize a palette to reflect your taste and style. There is no right or wrong when it comes to color!

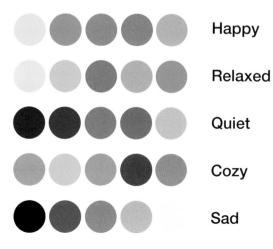

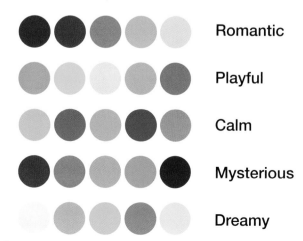

Crafting Tips

Here's where the real fun starts! You can use your colored stickers to add a personal touch to just about anything. Whether you want to dress up a wall in your home, decorate a pretty package for gifting, or embellish a craft, you can do it with the stickers in this book.

Here are some creative ideas for using these stickers:

Personalize: Of course you can spell out any word you want with these stickers, but here's another great idea: use one, two, or three letters to monogram items with your initials. No one will mistake your projects for anything other than your own personal creations!

Mix and Match: Create a one-of-a-kind work of art by mixing and matching stickers to make a look that is perfectly "you." Each book in the *Color Your Own Stickers* series is organized into a specific theme with stickers in various sizes that coordinate well. Also be sure to check out the other books in the series—by mixing designs from multiple books, you can really create unique compositions.

Speak Any Language: This book contains the standard English alphabet, but it also has an assortment of accents that you can use to spell out foreign words. And if you don't see exactly what you need, make it yourself! Just cut out whatever detail your word requires from any sticker to create your own accents and symbols.

Go Borderless: You'll notice that each sticker has a white border around it, which makes the stickers really pop on different backgrounds! However, you always have the option to add color to the border; or, you can clip your stickers so that you have a borderless edge.

FROM THIS...

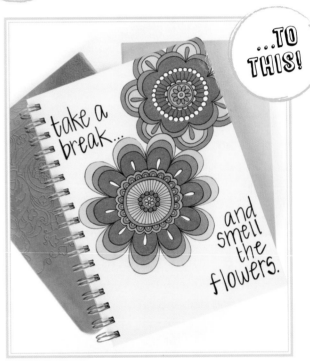

...TO THIS!

take a break...
and smell the flowers.

Tip: If you decide to display your sticker on something outdoors, be sure to polish it with a coat of decoupage medium (like Mod Podge) or clear acrylic to protect the sticker.

Turn the page to get started!

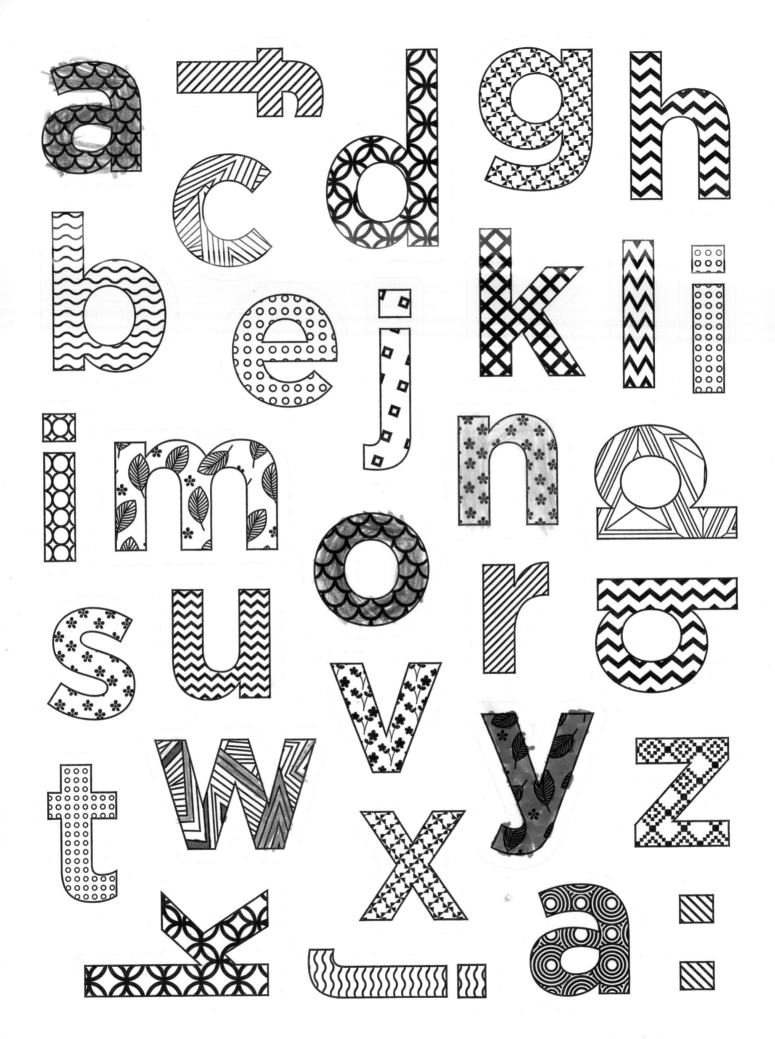

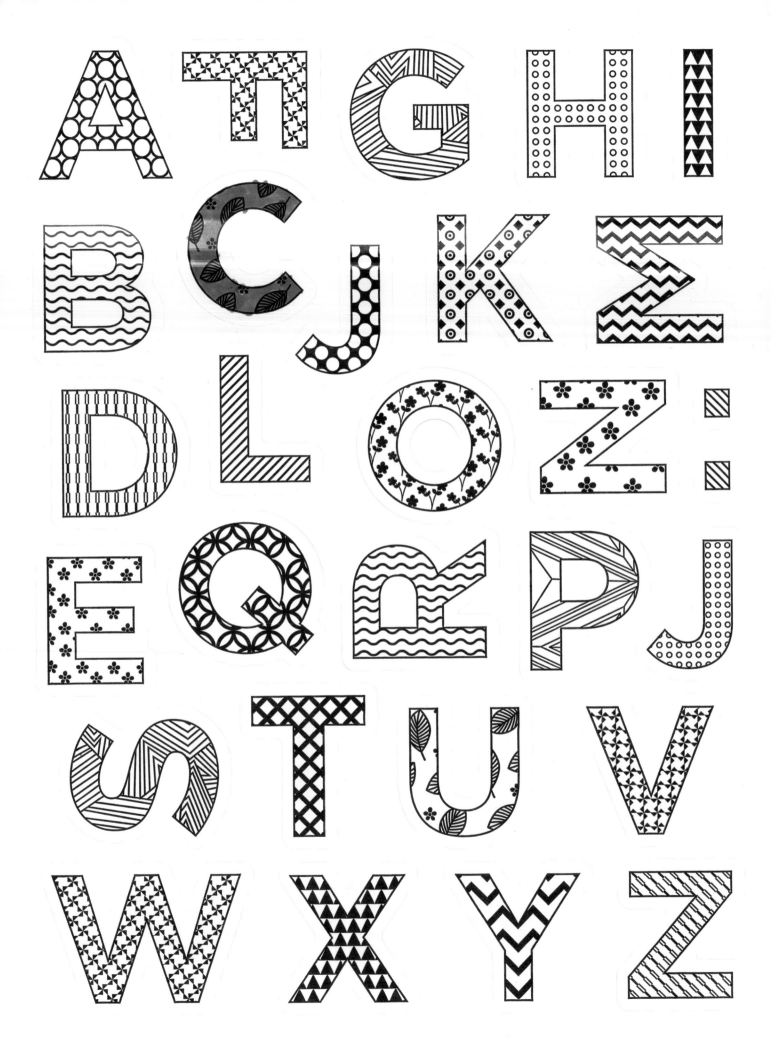

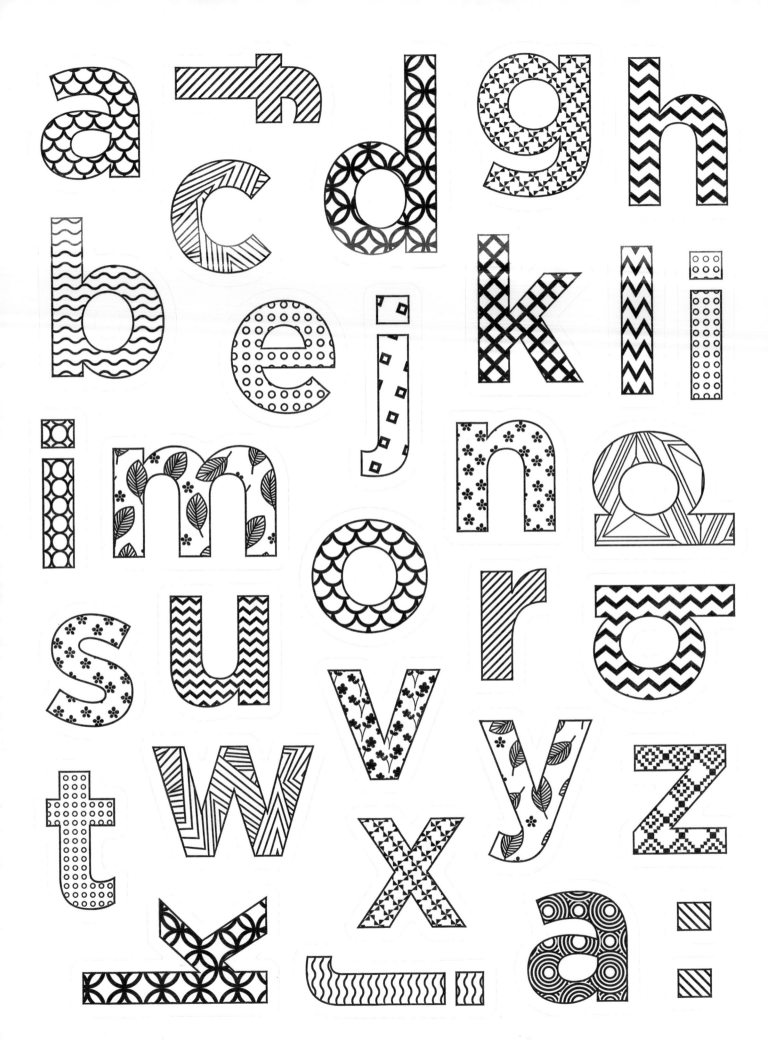

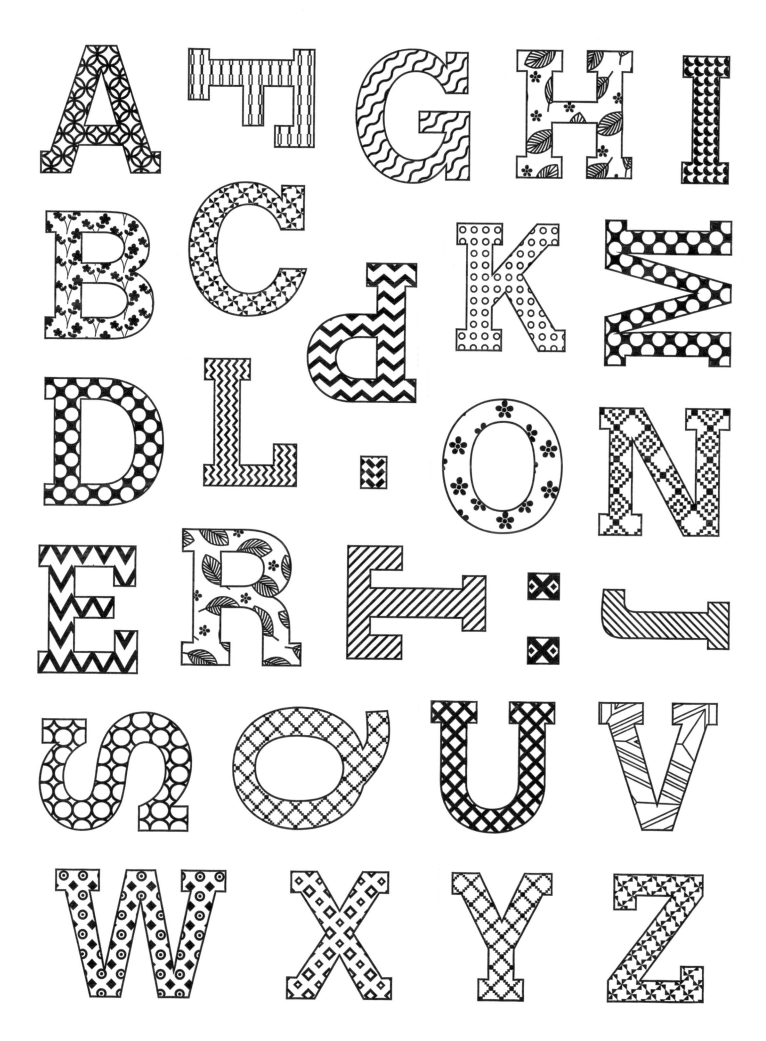

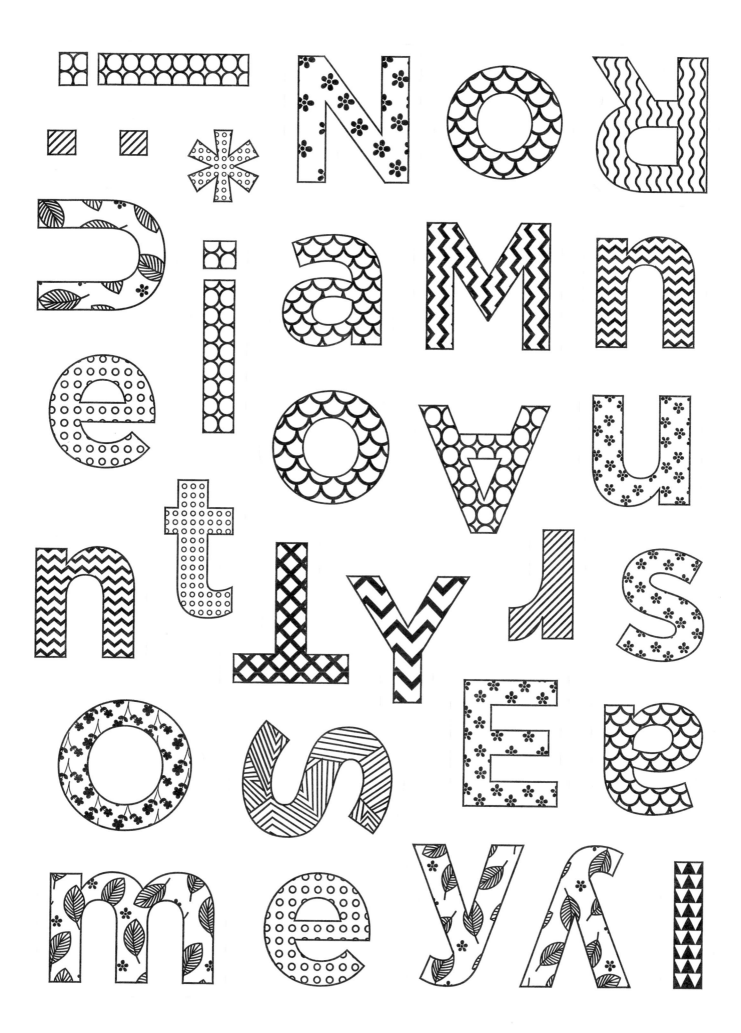

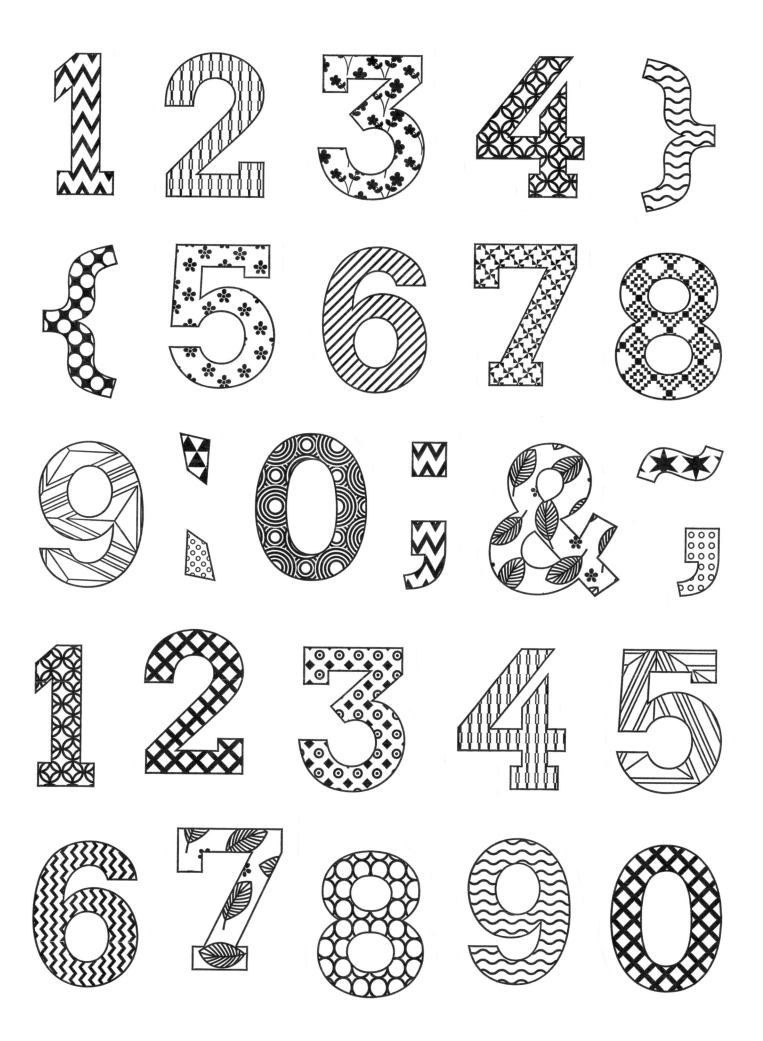

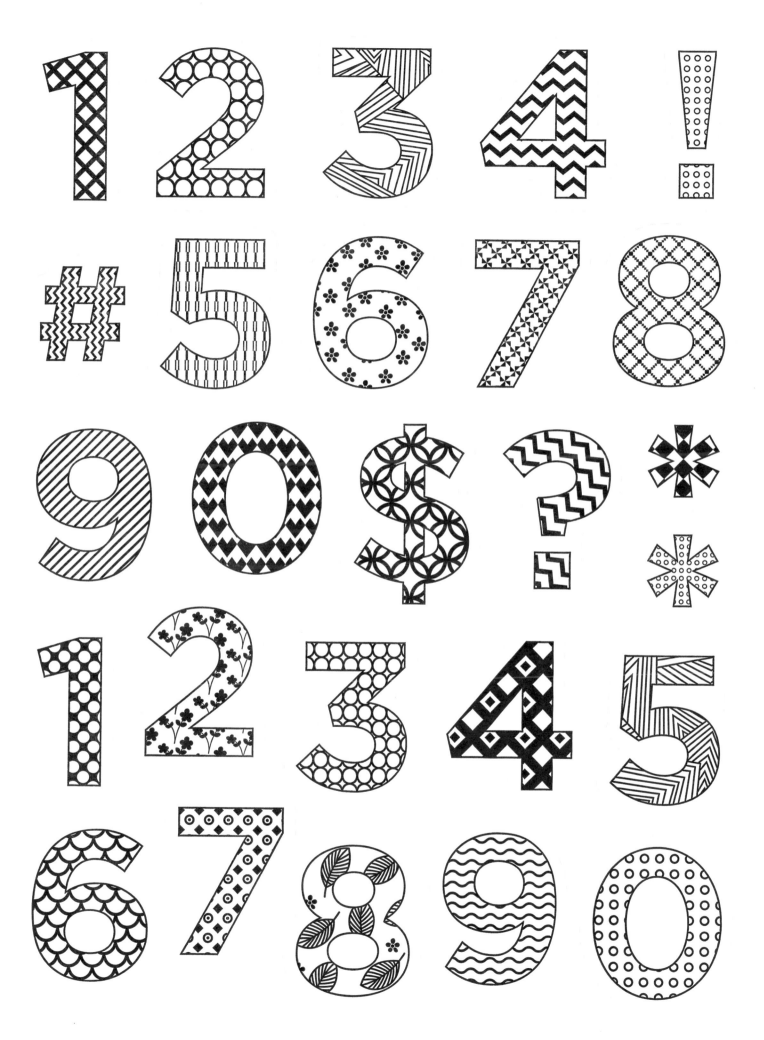

Idea Gallery

You can create tons of stylish crafts, home décor accents, and gifts with stickers that you colored yourself! The projects on these pages use a variety of stickers from across the *Color Your Own Stickers* series, but don't feel like you need to have the exact stickers shown. These projects are meant to serve as inspiration for your own projects and to jumpstart your imagination. Make it colorful and make it you!

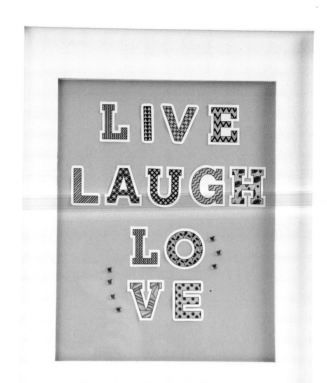

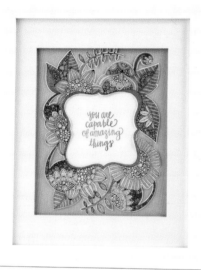

Custom wall art does not have to break the budget. This beautiful hand-colored border is embellished with a favorite quote and set in a matted frame. (Sticker from *Color Your Own Stickers Frames & Borders*)

Make your home décor personal by spelling out a favorite quote or mantra with colored stickers. Place the stickers on a coordinating piece of scrapbook paper, trim to size, and frame. (Stickers from *Color Your Own Stickers Letters & Numbers*)

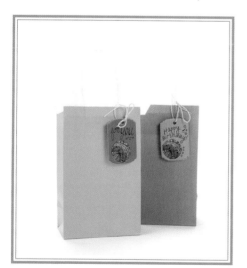

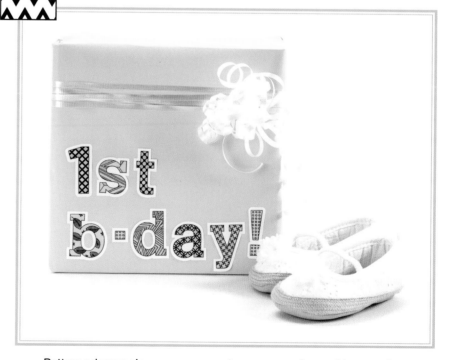

Wrapping gifts is sometimes more fun than giving them! Make every occasion special with these custom wooden gift tags, decorated with acrylic paint and colored stickers. (Stickers from *Color Your Own Stickers Frames & Borders*)

Patterned wrapping paper can get very expensive and is occasion-specific. Buy all-purpose solid colors and then personalize with colored stickers for any event, such as for baby's first birthday! (Stickers from *Color Your Own Stickers Letters & Numbers*)

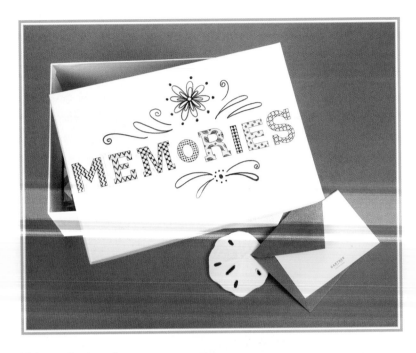

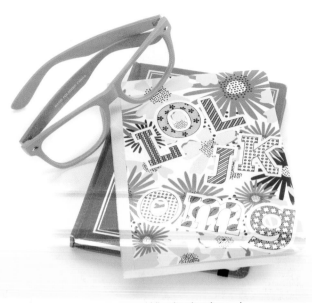

Make a display of treasured photos by labeling a box with hand-colored stickers. If you have lots of photos, get several boxes and use number stickers to mark the year. It's a practical and creative way to organize. (Stickers from *Color Your Own Stickers Letters & Numbers*)

Why be boring when you can go crazy with color? Combine various colors and stickers to make a super fun notebook. (Stickers from *Color Your Own Stickers Letters & Numbers*)

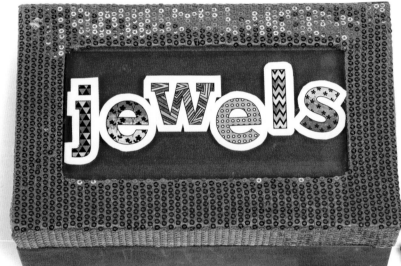

Who says less is more? This blinged-out box gets even more special with colored letter stickers that spell out what's inside. A great craft idea for sleepovers and birthday parties. (Stickers from *Color Your Own Stickers Letters & Numbers*)

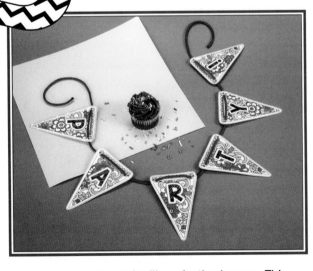

Nothing says party quite like a festive banner. This example was made by gluing individual flag stickers onto heavy cardstock and then stringing them together with a coordinating cord. (Stickers from *Color Your Own Stickers Party*)

This is a great project to showcase a larger sticker that you have colored. Simply find a wooden box at the craft store, paint the inside and outside in coordinating colors, and attach your sticker. What a statement! (Sticker from *Color Your Own Stickers Live, Laugh, Love*)

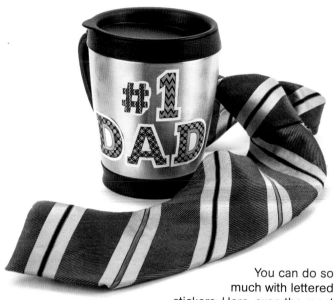

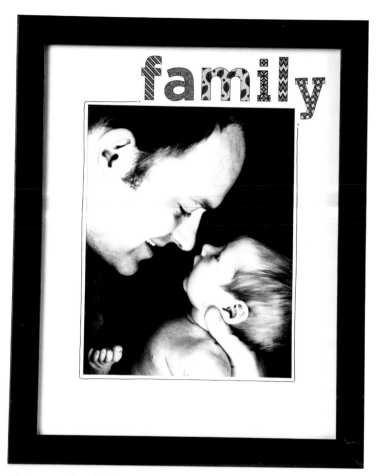

You can do so much with lettered stickers. Here, even the most basic mug gets personalized to make a memorable gift for Dad. (Stickers from *Color Your Own Stickers Letters & Numbers*)

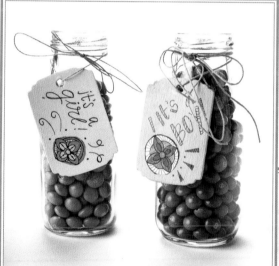

Make your family photographs even more special by displaying them in a frame that you made. You can purchase an unfinished frame at the craft store and paint it, or you can simply embellish a ready-made frame with colored stickers. (Stickers from *Color Your Own Stickers Letters & Numbers*)

Pink or blue, we welcome you! Embellish baby shower favors with mini mandala tags in pink and blue. (Stickers from *Color Your Own Stickers Mandalas*)

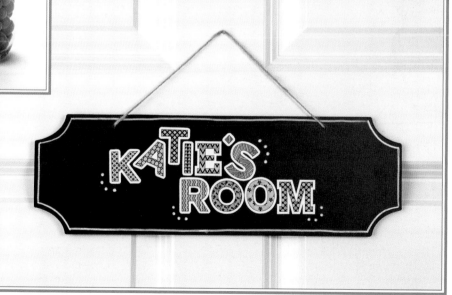

Make this easy room sign with a basic wooden blank (found at your local craft store). Base paint with black chalkboard paint, outline with a white paint pen, and attach your colored stickers. Be creative with your letter arranging as shown. (Stickers from *Color Your Own Stickers Letters & Numbers*)

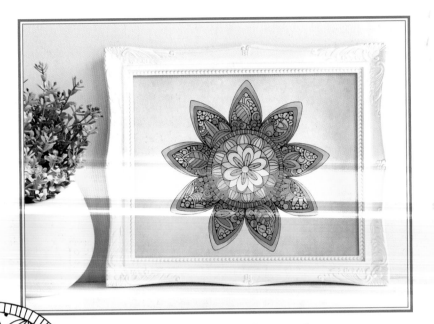

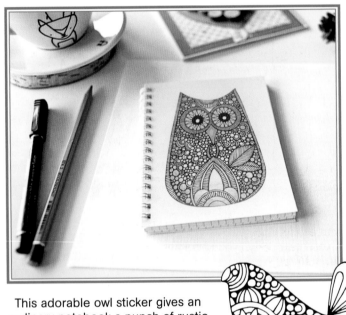

Why be like everyone else? Personalize your cell phone with colored stickers to add personality and pizazz. (Stickers from *Color Your Own Stickers Flowers*)

Wall art can be expensive, but not when you make your own. Just paint a thin wash of watercolor over neutral scrapbook paper and add a large mandala sticker. Beautiful and affordable! (Sticker from *Color Your Own Stickers Mandalas*)

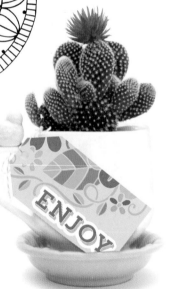

You don't need to spend a lot of money on gift giving. A simple plant with a hand-colored tag will brighten anyone's day. (Sticker from *Color Your Own Stickers Party*)

This adorable owl sticker gives an ordinary notebook a punch of rustic chic style. (Sticker from *Color Your Own Stickers Nature*)

Electronics don't have to be cold and boring—liven up your laptop with a gorgeous colored mandala. (Sticker from *Color Your Own Stickers Inspirations*)

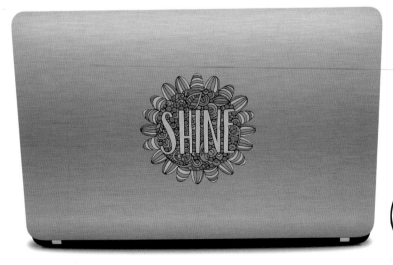